Hugh Casson's
CAMBRIDGE

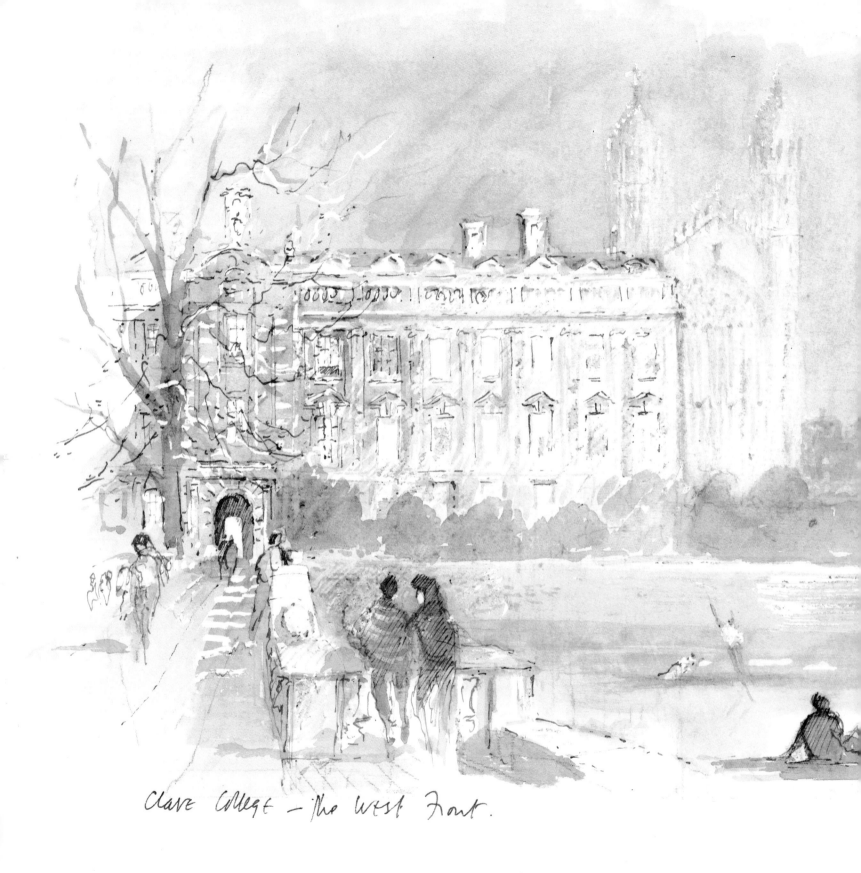

Clare College — The West Front.

HUGH CASSON'S
CAMBRIDGE

I have been lucky enough to receive much help, advice and
hospitality from the members, officers and staff of all the
colleges discussed in this book. I hope any inaccuracies will
be forgiven, any misjudgements excused and any
discoveries enjoyed.

Phaidon Press Limited
140 Kensington Church Street, London W8 4BN

Published in association with The K.S Giniger Company, Inc.
250 West 57th Street, New York, NY 10107, USA.

First published in 1992
Reprinted 1992, 1993
© 1992 Phaidon Press Limited
Text and illustrations © Hugh Casson

ISBN 0 7148 2459 3

A CIP catalogue record for this book is available
from the British Library.

Printed in Singapore

Contents

For my dear grandchildren Joshua, Emily, Caspar, Rosie and Matthew.

INTRODUCTION

Fens to the north, forest and scrub to the south. Four roads and a sluggish river meeting in a busy little mud-and-timber market town – cold, damp, misty and flat. Not, it would seem, an obvious place in which to found a new university. Yet in other ways Cambridge's early history was appropriately conventional, featuring a Roman occupation, a Viking sacking, a Danish interregnum, and eventually the return to the status of a busy market town. But to the group of refugee scholars fleeing the riots and hangings of thirteenth-century Oxford it must have seemed comfortable, quiet and pleasantly remote from interference. The river provided regular – but not too regular – contact with the outside world, and a few religious houses promised reassuring company. The 'refugees' decided to stay.

In fact Cambridge's placidity was short-lived and it was not long before Town and Gown were at each other's throats. Neither side was remotely interested in the activities of the other. The dons despised, as some of them still do, money, industry and trade. The townsfolk smelled idleness and complacency among the academics. In a society that lived by the exchange of goods, learning seemed light on useful and saleable products. Furthermore, young scholars were often ill-behaved and the colleges claimed the privilege of Royal backing in promoting their own property developments, often appropriating the finest and most desirable sites. By 1350 no fewer than seven new colleges had been built and local tension became so bad that in 1381 the Bishop of Norwich had to send in the Lancers to quell disturbances.

During the Civil War the frosty Town-Gown relationship worsened, with the former supporting the Puritans, the latter firmly Royalist and sending college silver to London for safety. (The local MP Oliver Cromwell was so irritated by this act that he imprisoned three heads of colleges in the Tower.)

The history of Cambridge is turbulent because not even a university still

popularly believed to be a place where dons drowse in their chapel stalls can stand aside from world affairs. Scholarship had to survive despite plagues and riots, Royal whims and ducal pressures, the mutilation or destruction of college treasures, fierce religious controversies, and centuries of resistance to ecclesiastical domination, all eventually culminating in the 'infiltration' of women, two world wars, student unrest and, more recently, vacillating government policies and shortage of money.

In his masterly survey of what he calls 'Our Age' Lord Annan, formerly Provost of King's, charts the twisting course followed by Cambridge in the first part of this century: the granite strength of the public school ethic where conduct was, and still seems to be, considered more important than ideas; the slowness to recognize the sparkling new creative waves made by post-Impressionism, the influence of T. S. Eliot, First World War pacifism and the arrival of Marxism; the spreading surf of homosexuality; the incoming tide of female students; another war; 'the cult of being amused and amusing'; and the recent worship of personal success and 'the image'. And when it comes to the latter, why not? Young people turning against their fathers' ideas are wise to make use of this interval when they can look around without being too serious, before embarking upon their uncertain future.

Nevertheless, a grey thread runs through these colourful years, with the establishment showing a persistent ignorance of, and lack of interest in, the world of design, industry and production, a weakness which has branded thousands of unbookish school children as 'failures', and has contributed to the decline of this country's economic health.

But what of the architectural background to this brief survey? In Cambridge the principal strip of courts and colleges measures approximately one mile by half a mile. And because the university was largely built to the west and the town to the east the colleges (unlike in Oxford) tend to stand aloof from the shopping streets so forming their own spectacular parade of highly individual buildings of every period, style and material, following the wandering line of the river bank. It seems likely that Nikolaus Pevsner's forecast that the 'Backs' will eventually become the 'Fronts' will soon be realised. Meanwhile the cynics argue that this picture of green turf and ancient stonework, of elegant spires and huge trees standing up to their ankles in

St Johns —
Gateway to The Backs

pools of shadow has been especially devised by the university to encourage stability and conservatism in the young.

The physical separation of Town and Gown has to date been beneficial for it helps alleviate one of Cambridge's great contemporary problems, the congestion resulting from traffic and tourism. And these pressures are increasing rapidly, for Cambridge is a place of great and inexhaustible beauty and deep historical interest. All the more impertinent, perhaps, is the attempt in these few pages to describe its variety, spaces, textures, and silhouettes. The only defence is to advance my modest aims.

This is not a guide book or a history (there are plenty of these). It is primarily an illustrated notebook of what has caught my eye and interest over many years in and among the colleges. There is nothing here about the town, nor the university buildings housing lecture rooms, libraries, and laboratories. Stained glass, silver, manuscripts, vestments and horticulture are not discussed, and modern architecture receives far less attention that it deserves, considering what a splendid museum of twentieth-century styles and architecture Cambridge presents, even if one wishes sometimes the architects had passed through The Gate of Humility at Caius. The five new post-war colleges are unfinished and unmentioned. There are sadly far too few comments on Cambridge personalitites – the sages and frauds, eccentrics, 'originals' and bullies – of which there are many. There are no footnotes and as few dates as possible. But I hope that at least some of the enjoyment I have had in compiling the book will be shared by those who leaf through its pages. I hope they will be encouraged to visit Cambridge many times, to enjoy what I believe to be the most beautiful university in the world.

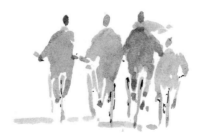

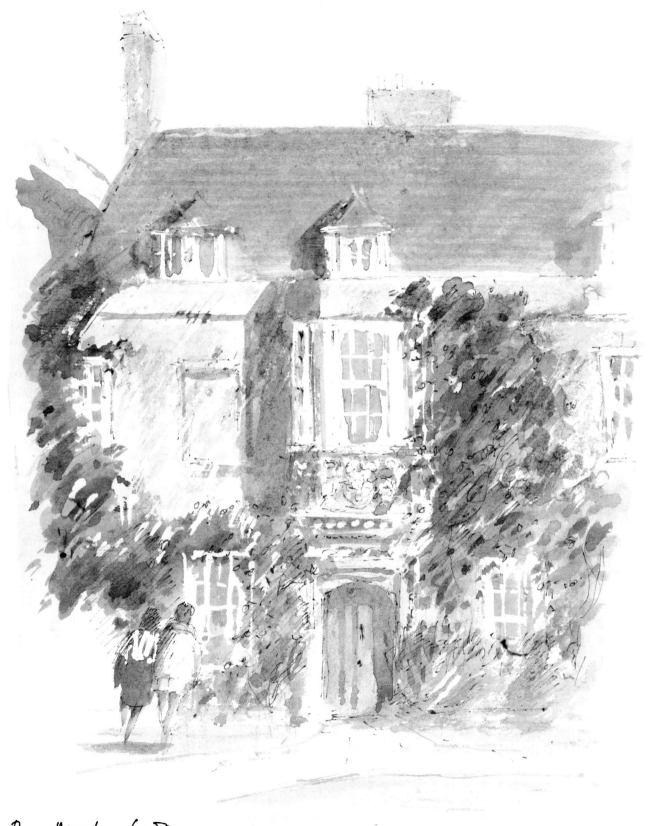

The Masters Lodge

CHRIST'S

COLLEGE

Like a number of Cambridge colleges Christ's guaranteed its existence by being founded twice, first in the fifteenth century when it unwisely got in the way of Royal proposals for King's College and was asked to move over, and second by Lady Margaret Beaufort on its present site. She was a kind woman, and fond of the college where she kept rooms. Apparently she once publicly rebuked the Dean for his intemperate scolding of a scholar, leaning from her bay window to call out '*lente lente*'. The college rules were strict even by the standards of the day and demanded clean surplices, no women, drink or dogs and that Latin be spoken at all times. Table napkins were compulsory, and fines imposed for wiping fingers on the tablecloth.

Like its neighbour Emmanuel, Christ's presents a quiet, formal face to the street and an equally formal back facade to First Court which, unusually for Cambridge, retains for the most part its cosy two-and-a-half storey height. The chapel, to the cost of which Queen Elizabeth I and Sir Francis Drake contributed, is a bit gloomy, but possesses some handsome glass, a black and white marble floor, splendid monuments and a pretty organ that springs dramatically out of the wall. A fine brass eagle presides fiercely over the ante chapel. The turreted gateway carries the horns of two mythical beasts – apparently made to rotate rather like helicopter blades – and Lady Beaufort's arms carved in stone. This can also be seen over the front door of the Master's Lodge, making it one of the most seductive doorways in Cambridge. Richly modest, it draws the eye more invitingly than the Hall rebuilt in 1870 by Sir Gilbert Scott.

A half-hearted attempt at a formal Second Court was abandoned and the college disintegrates into a pleasant rambling landscape in which the buildings stand as irresolute as warships at anchor in conflicting tides until order is re-imposed by Third Court. From this point on the college dissolves into